Recollections of

Henri Rousseau

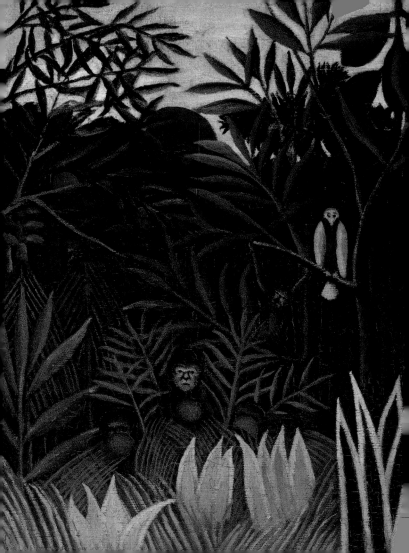

Recollections of Henri Rousseau

Wilhelm Uhde

introduced by
Nancy Ireson

The J. Paul Getty Museum, Los Angeles

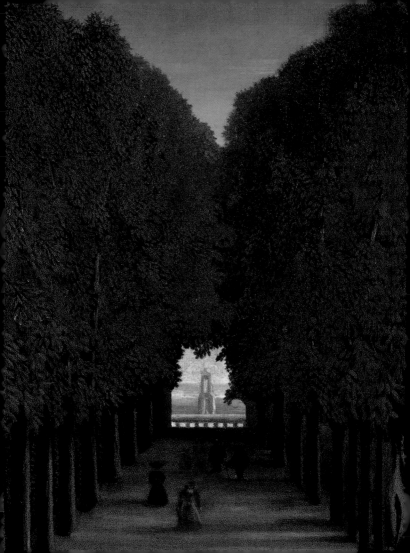

CONTENTS

Opposite: Avenue in the Park at Saint-Cloud, 1908

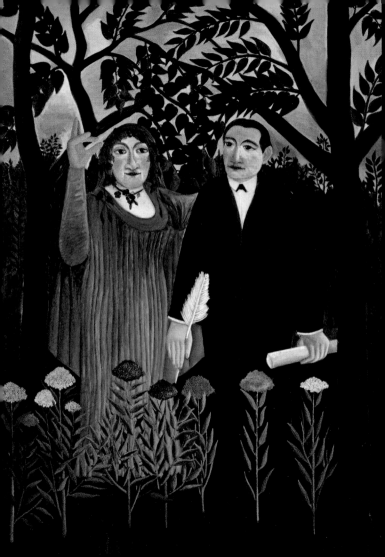

INTRODUCTION

NANCY IRESON

Only a handful of the biographers who wrote about Rousseau in the first half of the twentieth century had known the painter himself. Wilhelm Uhde, the author of this memoir, was one of them. He had been a frequent visitor to the artist's studio on the Rue Perrel and it was there, through looking and listening, that he built up his unique picture of 'le Douanier'. The text he created—published just months after the artist's death in September 1910—was the first monograph to describe this extraordinary man. The text in this volume—in an author-approved translation—is a revised version of that early account.

Uhde was born in Germany in 1874. He studied law at university but, having travelled to Florence, he developed a passion for art history. Subsequently, frustrated by the lack of intellectual freedom in his homeland, he moved to Paris at the age of thirty. The year was 1904 and, as an art-lover, the young man began to frequent the various exhibitions of the new avant-garde. Excited

Opposite: The Muse Inspiring the Poet (second version), 1909

by what he saw—and particularly by the work of the 'Fauve' painters—he lost no time in adopting their cause. He bartered with the artists he came to know so well and, though his means were limited, he soon became one of the most influential of the city's *dénicheurs* (bargain-hunters). Through his charm and his skills at negotiation, he managed to purchase works by Picasso, Braque, Derain and Dufy. Some he sold; others he kept for his own collection. In 1908, in a marriage of convenience, he married the painter Sonia Terk. This move enabled her to stay in France and, seemingly, allowed Uhde to conceal his homosexuality.

From his very first years in Paris, Uhde would have known of Rousseau's work. In 1905, at the Salon d'Automne, the artist's *Hungry Lion* (Fondation Beyeler, Basel, illustrated pp. 46-47) had caused quite a sensation. Rousseau was also a regular contributor to the Salon des Indépendants, a jury-free society to which he had belonged since 1886. However, even though Rousseau was in his sixties by this time, he was yet to find real success as a painter. His works often attracted little more than pity or derision. Thus in the spring of 1907, when he displayed *The Representatives of Foreign Powers Coming to Greet the Republic as a Sign of Peace* (Musée Picasso, Paris, illustrated opposite) his works were still a source of amusement for visitors. This canvas must be the image that

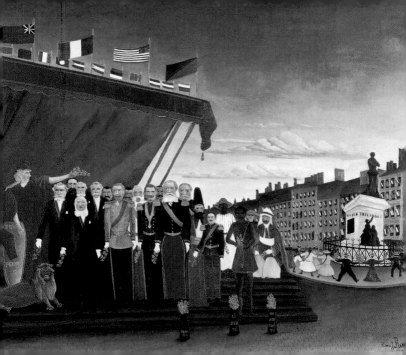

Uhde refers to in his text as 'The Sovereigns'. 'Anyone who suggested that the work might have artistic merits would have been rushed off to the asylum at Charenton,' he remembered.

Perhaps Uhde himself had harboured reservations at that point. However, thanks to Robert Delaunay, the dealer would soon take the artist seriously. Delaunay was one of the other painters in whom Uhde took an interest and the dealer respected his opinion (he divorced Sonia Terk, so that she and Delaunay could marry, in 1909). Both Rousseau and Delaunay were exhibitors at the Salon des Indépendants and it was there that they had met in 1906. They had become friends and Delaunay, young and from a rather privileged background, had been shocked at his friend's financial hardships. He decided to try and help 'le Douanier' to make a living from his art and persuaded his mother to furnish Rousseau with a commission.

Berthe Delaunay was a keen socialite who had travelled extensively. The painting that Rousseau made for her—supposedly based upon her tales of India—was *The Snake Charmer* (Musée d'Orsay, Paris; illustrated pp. 16-17). Faced with this extraordinary image, it seems, Uhde was compelled to find out more about the artist responsible. This canvas showed a mysterious, gifted figure that attracted the viewer but seemed unfamiliar:

one as exceptional and intriguing, perhaps, as Rousseau himself. Thus, over the next few years, the dealer nurtured his acquaintance with the painter. 'It did not take me long to realise how passionately he devoted himself to mastering the teeming visions of his brain,' Uhde recalled. He purchased works and he attended the concerts that the artist organised in his home. It was someone he knew—an old painter who played the violin, who lived for art, who had suffered the trials of life—whom he tried to capture in his biography.

Uhde's personal approach was important. Already, even within the painter's lifetime, the dealer's contemporaries had begun to mythologise the artist. By outlining the details of Rousseau's life, in contrast, Uhde took on the task of refuting some of those preconceptions. Some writers, for instance, had believed that Rousseau was a Breton and had treated his painting as though it was folk art. The dealer explained that the artist was actually from Laval, a market town in the Mayenne. Others persisted in calling Rousseau 'le Douanier', the 'customs man', in reference to the years that the painter had spent working for the civil service. Uhde wrote that Rousseau had in fact worked for the Octroi, a municipal service

Overleaf: The Sleeping Gypsy, 1897; first shown in public at the 13th Salon des Indépendants

II

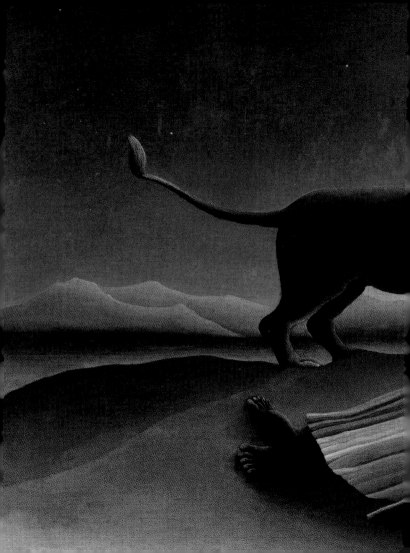

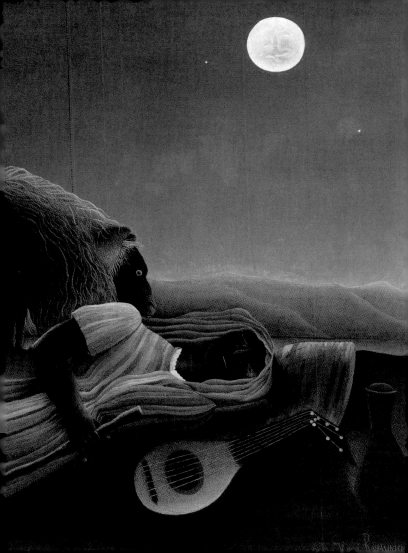

that imposed duty on goods entering the city. Thus he showed that the 'Douanier' sobriquet was inaccurate and, in relating stories of how the artist had been ridiculed by his colleagues, he implied that if Rousseau did not belong to the avant-garde world he had also stood out from his petit-bourgeois peers.

Most importantly, then, Uhde conveyed the message that appearances could be misleading. 'Behind the façade of the poor little customs man lay a rich, strong and mysterious personality,' he wrote in the first version of his text. He went on to describe how the artist worked during the years of their acquaintance: in a small studio, in an unglamorous district of Paris, in close proximity to his lower-middle-class neighbours. Significantly, too, he tried to stop speculation that was rife at the time as to which avant-garde figure had 'discovered' Rousseau. He framed the question as irrelevant: 'Rousseau's sense of artistic mission was so strong that he required no external stimulus.' Indeed, since subsequent research has revealed that neither Jarry nor Gauguin was the first to notice Rousseau (since his reputation built gradually through responses to his submissions at the Indépendants), he was right to do so. He also observed that – contrary to popular opinion—'le Douanier' was not literally 'naïve'. In the nineteenth century *'naïveté'*, in terms of innocence and freshness, had been a desirable quality for

artists to nurture in their work and Rousseau himself had claimed that he had 'kept his *naïveté*' on the recommendation of the academic painters he had met. The qualities that some viewers had thought resulted from the painter's simplicity or ignorance, in Uhde's text, were recast as stylistic choices.

Uhde emphasised all that was unique about Rousseau. He described 'le Douanier' as a timeless artist, one who could capture something more than a physical likeness or a fleeting impression. Once again, responding to the criticisms that his contemporaries had levied at the artist, he argued that it was of little matter if Rousseau's portraits did not resemble their subjects. Uhde's Rousseau could sense the personality of a sitter. In this light, rather than a simple description of a face, the *Portrait of a Lady* (Musée d'Orsay, Paris, illustrated p. 35), which Uhde believed was a portrait of the artist's first wife, became 'a hymn to youth and love'. The so-called 'lamp portraits', meanwhile, conveyed a wealth of domestic peace and harmony. This strategy not only allowed Uhde to extricate the artist from accusations of *naïveté* and ignorance, but also enabled him to align Rousseau with a whole lineage of great French painters from Poussin to Corot. In perhaps the most curious passage of the essay he described an occasion when, working on one of his jungle canvases, Rousseau claimed his late wife guided

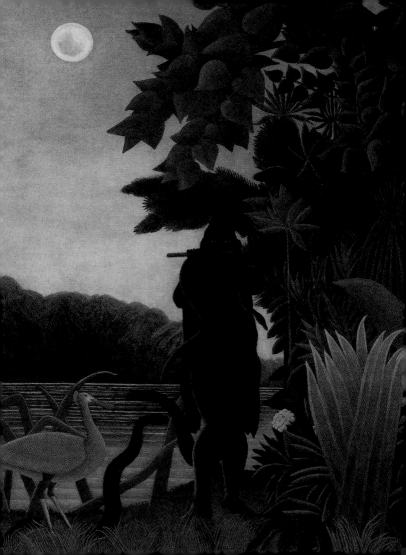

Th

his hand as he painted. However, though it may have invited speculation as to whether the artist had supernatural powers, the strategy underlined Uhde's belief that 'le Douanier' had been an exceptionally gifted artist. He conveyed his message convincingly for, in the years that followed, Rousseau's reputation grew at an extraordinary rate. The market value of his paintings soared, and by the 1920s numerous monographs on the artist appeared. Uhde's text proved a touchstone for them all.

Uhde had stressed in his text that Rousseau had been calculating in his relations with those around him. Perhaps 'le Douanier' was occasionally rather economical with the truth in his discussions with the dealer himself. Uhde had believed that Rousseau had served as a soldier in Mexico, and had related as much in his 1911 text, but this was untrue. The artist had never left France. It was to correct such mistakes—as well as to cast Rousseau in the wider category of 'primitive' art—that Uhde revised his monograph in the 1940s. However, since Rousseau probably started the Mexico rumour himself, it is understandable that Uhde had fallen for the tale. When he came to the biography again, to produce the present version, he worded his account of the painter's military career more carefully. 'Le Douanier' claimed to have seen active service in the Franco-Prussian War, he wrote. He was right to proceed with caution, for here, it transpires,

was another example of 'le Douanier's' exaggeration:
Rousseau never reached the front line. Other minor
discrepancies—such as Uhde's assertion that the notori-
ous 'banquet Rousseau' marked the artist's acquittal in
a bank fraud case in the winter of 1907-8—could well
have arisen from his intimacy with his subject. Here the
dealer was writing about an informal gathering between
friends, one in which he himself had participated, and so
some confusion over dates was quite natural.

Upon revising his text in the 1940s Uhde did create
the impression that he was the first dealer to champion
'le Douanier'. In fact, as early as 1895, the dealer Am-
broise Vollard had tried to sell Rousseau's work. His
suggestion that the 300 francs the painter achieved for
To Celebrate the Baby (Kunstmuseum, Winterthur, illus-
trated p. 43) was the highest sum Rousseau ever achieved
was also misguided, for in 1909 Vollard purchased an
unidentified canvas for 400 francs, while Soffici and the
Baroness d'Oettinger (two early patrons) paid similar
sums for jungle scenes and a view of Paris. In contrast,
Uhde parted with no more than 200 francs for a single
work that year, but as a dealer he probably drove a hard
bargain. If perhaps less kindly than the last pages of the
memoir might indicate, in their commercial relations,

Overleaf: Artillerymen, c. 1893-95

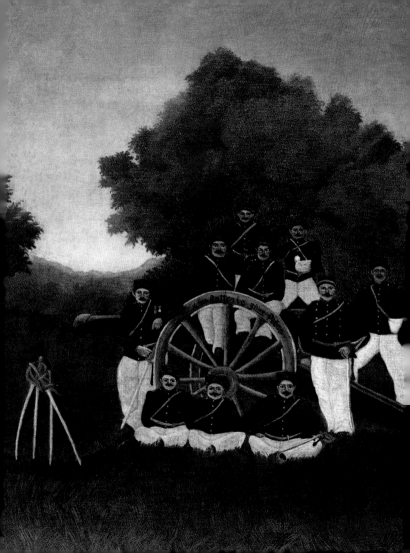

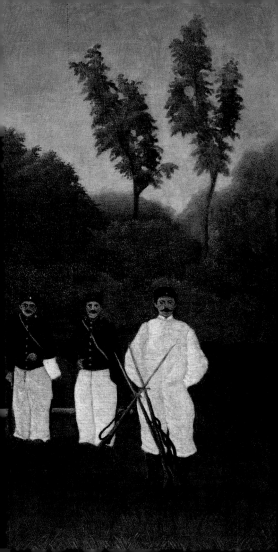

the fact that Uhde treated 'le Douanier' as he would have treated other avant-garde artists is testimony to how seriously he took Rousseau's art. To view Rousseau on a footing with other painters was a bold move: even in the 1920s some writers would criticise Uhde for having overstated the artist's importance.

Furthermore, in the wealth of detail that they offer, no other source can rival the *Recollections*. The dealer's account of his friend remains the most comprehensive contemporary account of the artist and his ways: a fascinating picture of an extraordinary individual. They convey a wonderful sense of discovery: that sense of discovery that the author must have felt, over one hundred years ago, when he made his first visit to Rousseau's home.

WILHELM UHDE

Recollections of
Henri Rousseau

1911

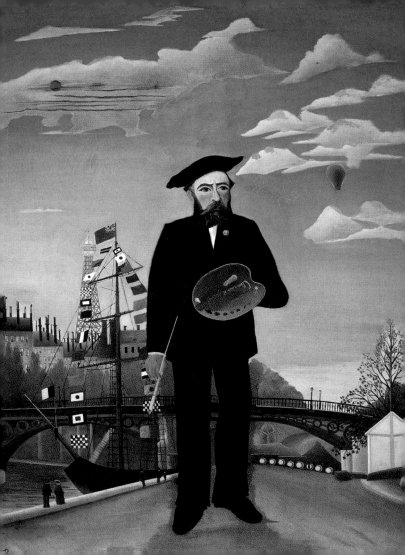

One Sunday, years before the First World War, I pushed my way through the crowds on the Rue de la Gaîeté, a bustling Left Bank street lined with playhouses and primitive cinemas and thronged with artists, tradesmen and lowlifes in a holiday mood. Leaving the Rue de la Gaîté, I crossed the Avenue du Maine into the narrower, quieter Rue Vercingétorix, which runs southwest across the Plaisance quarter out toward the fortifications of Paris. Then I turned right into a deserted little side-street only a few steps long and ending abruptly in a blank wall. This was, and is, the Rue Perrel.

In those days a plaster-moulder had a studio on the ground floor of one of the Rue Perrel's rickety houses. Upstairs were rooms which he rented out. A sign outside one of the rooms read: *Lessons in Diction, Music, Painting, Singing (Solfège)*. I knocked and walked in.

Henri Rousseau himself came to the door, taking both my hands in his and welcoming me in a voice as gentle and guileless as a child's. This was one of his 'at homes', and he was not wearing his usual paint-smudged smock. A number of guests were jammed into the little room—typical neighbourhood

Opposite: Myself, Portrait-Landscape, 1890

bourgeois, for the most part, accustomed to chicken once a week and *pot-au-feu* the rest, but also a few outsiders, including a couple of professional artists and a writer nobody ever heard of. Most of the crowd was gathered around an easel, looking at a picture. The picture was almost as large as the room itself— a weird primeval-jungle scene, with exotic vegetation and lurking wild beasts.[1]

'Well,' Rousseau said to a solemn-looking man dressed in black, 'what's your opinion?' There was a faintly insistent note in the question, as though he had already asked it once and had no reply. The solemn-looking man hemmed and hawed, but finally handed down his verdict:

'Rousseau, I'll tell you. That picture of yours in the last Indépendant show wasn't half bad, either.' Whereupon someone else broke in to ask why the foliage in the foreground wasn't darker, and a third remarked that it was plenty dark enough. A general argument ensued, with comments and criticisms from all sides.

Rousseau, meanwhile, turned to a young man who stood staring at the picture, apparently oblivious to the

(1) Probably the *Fight between a Tiger and a Buffalo*, 1908, Cleveland Museum of Art

debate. 'Well, my friend, what do you think?' Again I was struck by the simple charm of the Douanier's voice.

'It's good,' the young man answered. 'It's beautiful. In fact, I think it's the most beautiful thing you've ever done.'

'Ah then, it will be all right?' It was very important that it be all right, for the young man was a collector and had commissioned the picture. It was so very all right that he wanted to take it home with him then and there, but Rousseau refused. He explained that he had decided to change certain details, and then wanted to hang the picture in the coming *Salon d'Automne*.

He was, though, proud and pleased. At last he was getting occasional commissions, and he was sure the number would increase. His guests in general were also pleased, for here it was a leisurely Sunday, and there was wine to drink, and by their presence they were demonstrating that they knew something about art—perhaps more than their host himself. They lifted their glasses as someone called for a toast to Henri Rousseau.

• • •

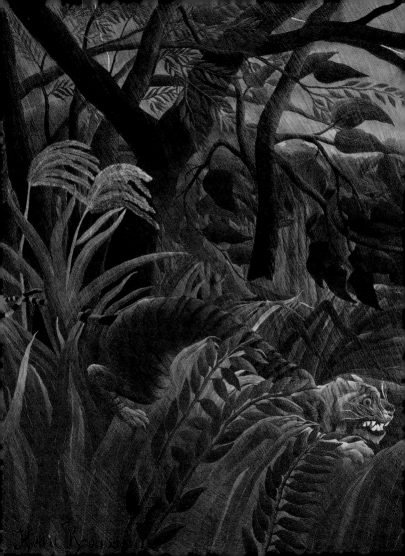

Surprise!, 1891.
Rousseau's first
jungle picture

WILHELM UHDE

Sitting along the wall was an old man who took no part in the ceremony. Instead, he gazed moodily out of the window, as though he found the subject of painting a bore and the assembled guests a lot of dolts. He was a former colleague of Rousseau's in the municipal toll service, like him a retired *gabelou* (Rousseau had never been in the national customs service and hence was not, strictly speaking, a douanier). He figured that he knew the host better than anyone else in the room.

What is more, he didn't think much of him... After all, what could you expect? Rousseau had been next to worthless in the service. He had never been allowed to do anything that required brains. His job had been to hang around the *quai* like a watchman, keeping an eye on the barges. How could you have trusted him with a more responsible job? To begin with, he believed in spirits and spooks. One evening, for example, the boys had rigged up a skeleton between wine barrels in the warehouse and jiggled it with a string. Along had come Rousseau, and what had he done? Instead of acting like a normal man, he had politely asked the damned thing whether it would like a drink!

Opposite: The Toll House (The Customs Post), c. 1890

What a simpleton! Besides, Rousseau had always been the silent sort, never willing to say much about anything or anybody. He had preferred to sneak off somewhere alone and fiddle with his pictures and paints. It had been the same wherever he was stationed—at the Pont de la Tournelle, out at the fortifications, at the Porte de Meudon.

No great loss to the service when the day came for him to quit! He ought to feel honoured that someone who had really done a decent job and earned his wages would come to see him at all. That crackpot an artist? Let nobody waste good breath spouting such nonsense! Why, practically everyone except 'Americans' laughed at Rousseau's pictures (he called all foreigners 'Americans'), and who didn't know that 'Americans' were easy marks? They fell for everything, and would 'collect' anything, from royal cigar butts to a half-wit's so-called art! Rousseau an artist? Well, well!... The old man sniffed contemptuously, and took a good slug of wine from his glass.

The years rolled by. Rousseau continued to paint. The pictures on his easel grew richer and mellower; he himself grew grayer and more stooped. Yet whenever I came to call, there sat the same old man on the same chair, as contemptuous as ever—a perfect symbol of the great philistine public whose

scorn and indifference have always broken artists' hearts.

• • •

Rousseau had a good deal of company, at that, for he knew many people and liked to entertain. The cot he slept in would be folded and stuck in a corner. His chairs would be arrayed as precisely as a squad of soldiers around the walls of the room. On the floor lay the cheap carpet a shopkeeper had let him have in exchange for three of his pictures. Jugs of wine stood waiting on the table. Guests of all types appeared, including almost always a lady with four daughters wearing flowers in their hair.

Likewise present, as a rule, were a number of Rousseau's art or music pupils. The eldest of these was 70-odd, and utterly untalented, but whenever asked how he was progressing, Rousseau would gravely answer, 'He's coming along.' Young painters and writers also showed up. Rousseau was interested in all the arts; painting was simply his favourite. He played the violin well, composed music, wrote poetry and plays. One of his plays,[1] incidentally, he sent to

(1) *La Vengeance d'une Orpheline Russe* ('The Revenge of a Russian Orphan'), 1899

the Comédie Française—which returned it, explaining politely that it would cost too much to produce. His soirées were supposed to be literary-philosophical affairs, but there was always much drinking, laughter and horseplay. Whenever the atmosphere became a trifle bacchantic, the mother and her four daughters with flowers in their hair would make a ladylike exit. By midnight things were often bacchantic for fair—perhaps with old Rousseau himself in the midst of the chaos, tootling a flute before the full-length portrait of his dead wife,[1] and dancing from foot to foot, the tears streaming from his eyes.

Most of the guests had a fine time at these parties, and probably only Rousseau's younger music pupils didn't find them exciting enough. For them, his so-called Examination Days were much more so. On such occasions, the fond parents would take seats around the room, having first shaken hands with the *maître*. The *maître*, much wrought up, would be dressed in his best black suit with the violet ribbon of the Palmes Académiques in his buttonhole (he had once taught drawing in a municipal school, and had been thus rewarded by the authorities).

(1) Probably the *Portrait of a Lady*, 1895-97, Musée d'Orsay

Opposite: Portrait of a Lady (The artist's first wife?), 1895-97

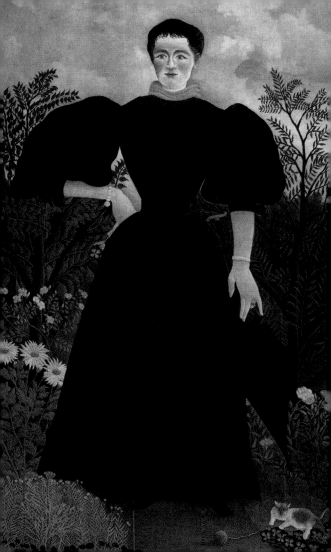

At last all was ready, and the examinations would begin. But they were soon concluded, for none of the pupils performed as expected. Some played the wrong selections, others deliberately wrong notes. Rousseau's pupils teased him endlessly, and could think up a new trick every day. Once they invited a group of people Rousseau didn't know to a soirée he hadn't planned. The arrival of the first two or three delighted the old man, for he felt that if strangers came to call, he must be getting famous. But the fourth guest made him wonder, and for the tenth he wouldn't even open the door.

Rousseau was in fact a great innocent, with little knowledge of the wiles of the world. His instinct was to believe that everybody was as honest as he, and in one case above all (as will appear) he was tragically mistaken. He looked for the good in people, and overlooked everything else, whether it was what they did for a living or even more obvious traits and facts. I, for example, was fairly young when we first met. One day I happened to make a remark that a young man would ordinarily not have made. From that moment forward Rousseau assumed that I was some thirty years older than I actually was. He talked of the days when we both had been boys. He asked a woman patently my senior whether she was my daughter, and a full-grown man whether he was my son. So little did

he know of life in general. As for the little we know of his life, that may be quickly summarised.

• • •

He was born in Laval, Department of Mayenne, in 1844, the son of a tinsmith. His mother is said to have been so excessively pious that she spent far more than the family could afford on delicacies to give the local clergy when they came to call. I do not believe—as I used to—the story about Rousseau's going to Mexico in the 1860's as a regimental musician in Maximilian's army. He was, however, a sergeant during the Franco-Prussian War, and claimed to have seen some front-line action.

Settling in Paris after the war, he entered the municipal toll service and began to paint in his spare time. There are a number of stories about how he happened to take up painting in the first place. According to one, he was urged to it by Alfred Jarry ('Père Ubu'), who also came from Laval and whose father had been a friend of Rousseau's father. According to another, Gauguin is supposed to have made a bet that any completely naïve person could paint if given a chance—and having met Rousseau, started him off. It is needless to argue whether such stories are true or false. Rousseau's sense of artistic mission

was so strong that he required no external stimulus. It is commonly believed that he was 40 or 41 when he began—i.e., that he began about 1885. But works dating from this period are technically so skilled that it may be taken for granted that he started earlier.

Earlier than that, at any rate, he fell in love with a Polish girl whom he idealised in a late picture, *The Dream*, as Yadwigha.[1] He married twice, and long outlived his second wife. By the first he had a daughter. She was taken from him at the age of about 15 and brought up elsewhere, for in his innocence he played the bachelor much too freely in her presence.

Always poor, he tried to eke out a living in various ways. For a time he made transcripts for a lawyer. Soon after leaving the toll service, he opened a little shop in which his wife sold pens, pencils, writing paper and his pictures. He entered (unsuccessfully) a prize competition for the decoration of public buildings,[2] and once drafted plans for an academy which was to be under his direction.

(1) 1910, Museum of Modern Art, New York. Illustrated pp. 66-67
(2) Possibly with *A Centennial of Independence*, 1892, J. Paul Getty Museum, Los Angeles, illustrated overleaf

Opposite: Carnival Evening, 1886: one of the first paintings Rousseau exhibited at the Salon des Indépendants

Overleaf: A Centennial of Independence, 1892

Despite his poverty, he found time to help others, and for a while served as an unpaid social worker and charity canvasser, going from door to door to collect alms. For himself he was content with little, and toward others more than generous. He once told a photographer who had reproduced one of his paintings, 'I can't afford to pay you in cash, but come around tomorrow and I'll give you six pictures for your trouble.' It should be borne in mind that he treasured his pictures above anything in the world. As for the photographer, he couldn't be bothered to fetch the six he had been promised—a decision he regretted later on. There are people who go through life as though they were special guests on earth; and then there are those whose joy is to give, rather than receive. These latter are few and far between. One of them was Henri Rousseau.

He earned a little cash by selling landscapes to his Plaisance neighbours, or by now and then doing a portrait for a small fee. One of his most charming portraits is that of a chubby child with a lapful of flowers.[1] This child stands on the lawn of a park or garden and holds up its dress in front with one hand

(1) *To Celebrate the Baby*, 1903, Kunstmuseum, Winterthur

Opposite: To Celebrate the Baby, 1903

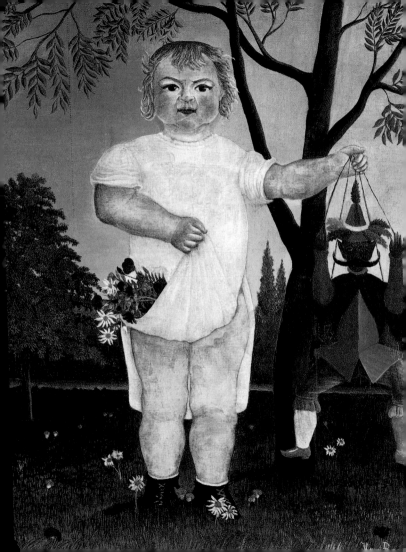

and dangles a puppet from the other. Rousseau received 300 francs for this portrait, which is the largest sum, I believe, he ever received for a painting. The child's parents couldn't afford even that, and had to relinquish the picture in settlement of a small laundry bill. On the whole, like most other artists, Rousseau did his best work when best paid. Whoever tried to take advantage of him money-wise—paying him in more or less worthless goods rather than in cash—as a rule got a less interesting picture. Rousseau was not always as simple as he seemed.

For years he exhibited his work at the annual Salon des Indépendants. It was the Indépendants who made his name known, and he who helped advertise them, in turn. For his pictures became the great attraction there, and Paris crowded in to look and laugh for two months every year. Curiosity-seekers craned their necks at his pictures as though at some comic incident on the boulevards; perfect strangers nudged one another and fell into friendly talk. I never heard such laughter, even at a circus, as when Rousseau's *The Sovereigns*[1] went on display. Anyone who suggested

(1) Probably *The Representatives of Foreign Powers Coming to Greet the Republic as a Sign of Peace*, 1907, Musée Picasso, Paris. Illustrated p. 9

that the work might have artistic merits would have been rushed off to the asylum at Charenton.

Now and then, however, along would come a young person who seemed to take Rousseau seriously. And, in fact, within a few years he had a place of honour at the *Salon d'Automne*. One of Maillol's handsomest sculptures stood in the middle of a small room, with a huge Rousseau jungle scene serving as background.[1] This triumph had not been engineered. It was due simply to the virtues of the picture, and won the Douanier earnest admirers. The public began to ask why the Gobelins didn't reproduce his works in tapestry.

Now there were more commissions—as many as three or four at a time. He worked at his easel day and night. Just when everything seemed to be going beautifully, he made his tragic mistake. An unscrupulous acquaintance whispered in his ear that there was an easy way for both of them to make a great deal of money. In his naïveté Rousseau agreed, not realising that his tempter was an out-and-out criminal. The upshot was that the old man was haled before a court of assizes, tried and convicted. His sentence

(1) *The Hungry Lion throws itself upon the Antelope*, 1905, Fondation Beyeler, Basel

Overleaf: The Hungry Lion throws itself upon the Antelope, 1905

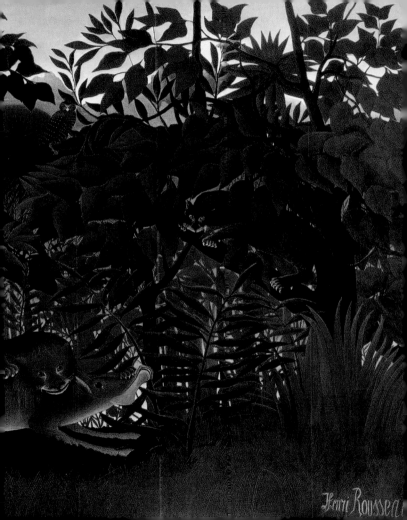

remitted under the provisions of the *loi Bérenger*, he beamed with gratitude. 'Je vous remercie, Monsieur le Président,' he told the judge; 'je ferai le portrait de votre dame.'*

Picasso arranged a banquet for Rousseau once this unfortunate incident was closed. The young artists who had become his especial admirers attended en masse and toasted the guest of honour at such length that eventually he fell asleep, overcome with the joys of the occasion.

• • •

There was not much time for joy remaining. One evening he visited me in the ancient cloister on the Boulevard des Invalides in which I then made my home. The high windows were open wide to the breeze drifting in from the park across the way, and it was so dark I could scarcely see his features. But I

* "Thank you, your honour. I'll paint a portrait of your wife." The *loi Bérenger*, under which Rousseau escaped jail, is an act for the relief of first offenders. Rousseau's accomplice, Sauvage by name, was one of his former music pupils and a clerk in the Bank of France. Persuading the old man to open an account under a pseudonym, he forged papers which indicated a sizeable credit in this account, then paid Rousseau a small sum for his trouble and made off with the rest. Sauvage's sentence was five years. (Tr.)

gathered from an undertone in his voice that he was in a solemn mood. So he was. He fell to talking about war, and he hated war. 'If a king tries to start a war,' he declared with great gravity, 'a mother should go to him and forbid it.'

On July 14, 1910—the last Quatorze Juillet he lived to celebrate—I went to his room. There were other callers, and he was dressed for the holiday and on the point of pouring some wine. 'Do you love peace?' he demanded, and when I said yes, we all drank to peace. Then he took me by the hand, led me to the window and pointed out the German flag—my native flag—fluttering among the others below.

On a hot August day a few weeks later I knocked at his door. Receiving no answer, I walked in. He lay on his bed, ghastly pale. There was a painful sore on his leg. He was so apathetic that he didn't even brush away the flies which buzzed around his face, but he did talk of getting up soon and going on with his painting. Some days after that, I came home to find a note saying that he was dying in the Necker Hospital and had begged me to come as soon as possible. I rushed there and found him sinking fast. For hours I sat by his bed, and he clasped my hand tightly. Two days later he died. He was 66 years old.

• • •

WILHELM UHDE

With the death of Henri Rousseau, a precious spirit passed away. What made his life so precious and his death so great a loss? Was it his childlike candour, his innocence of the world and its compromises and evils? Was it that he embodied the words of the Gospel: 'Blessed are the poor in spirit, for theirs is the kingdom of heaven'? Was it the fantasy and imagination embodied in his art, the tenderly heroic and refreshingly quixotic aspects of his nature?

All such questions, of course, will be answered differently by different men. I myself believe that Rousseau's greatest quality was greater than any of these. It was his emotional self-dedication, his endurance, his overwhelming love and passion for, and faith in, life. Rarely in any given century are there men of similar emotional force and conviction. Rousseau embraced life and art as though they were identical. He loved as only a great artist can love, and painted as only a great lover can paint.

His love was not the ordinary bourgeois sort— throbbing and intense in youth, then gradually relaxed, and finally quiescent. The passion pulsed hotly

Opposite: Past and Present, 1899. In this self-portrait with his second wife Rousseau also shows their previous spouses; he wrote an accompanying poem reaffirming their continued faithfulness to the departed even in their new marriage

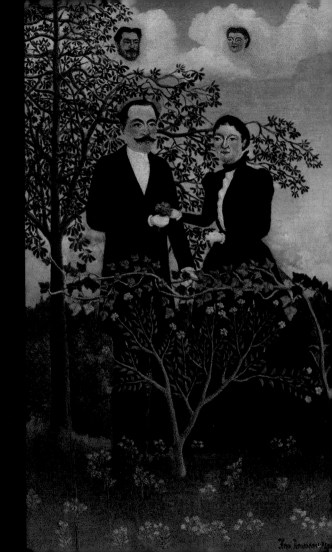

as long as he lived. His two marriages and various affairs expressed the deepest hunger of his soul as well as the urgency of his physical powers. To love and be loved was his great desire. He went through life bearing his heart in his hand as an offering. He wanted to marry every woman he met—and, significantly enough, usually testified to his love with the gift of a picture.

Even in his last years he wanted to marry, and chose a maiden lady of 54, daughter of a former colleague in the toll service. The woman wasn't interested, and her father concluded that Rousseau had become senile. But the Douanier would not be put off. He slaved at his painting to earn thousands of francs extra to buy her gifts; he haunted her doorstep. One day he begged her to arrange the publication of the banns. Hoping to be rid of him, she brusquely told him to go and do it himself.

Taking her at her word, Rousseau filed the necessary papers, and on the appointed day knocked at her door with the friend he had chosen as best man. The happy hour, he announced, had come.

'The happy hour for what?' she inquired coldly. 'For our wedding,' Rousseau answered. The woman flew into a rage and threw him out of the house. Later, as Rousseau wiped away the tears, his friend

suggested that he ask the woman to return the valuable gifts he had given her. Rousseau wouldn't hear of it. He intended, he said, to keep the valuable gifts she had given him: snips of ribbon she had worn and other trifling mementos. 'But she's turned you down,' the friend reminded him; 'what else can you do?' 'I'll keep right on,' Rousseau replied.

Which is exactly what he did do. Soon after his rebuff, he came to me and said he had a favour to ask. Would I please draw up a certificate to the effect that he was as intelligent as the next man and that I owned and admired a number of his pictures? I gather that he asked as much of other people he knew, then took the certificates to the woman's father, hoping still to convince him that he would make a suitable son-in-law. It was not in his character to admit defeat. Even as he lay dying, he sent tender messages to the woman—all in vain.

The desire to love and be loved, basic in human nature, is paralleled by the artist's yearning to create and achieve recognition as a creator. Rousseau gave more than 25 years of his life to his art. He gave every available moment, sleeping in his clothes to save time, even neglecting the sore that led to his death. During his last days in the hospital, no longer strong enough to eat, he still found strength to discuss a half-finished

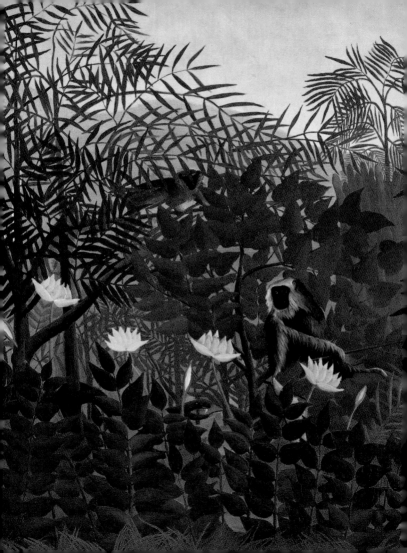

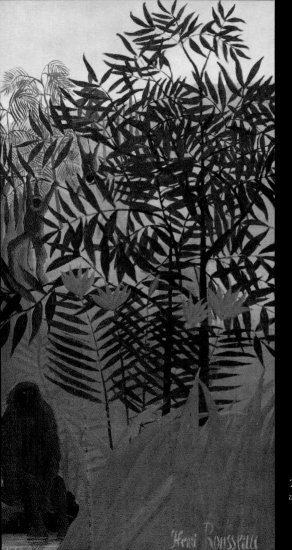

Tropical Forest with Monkeys, 191

Heni Rousseau

picture and to deplore the delay caused by his illness. He brought to bear on the entire course of his work that sort of intense and indefatigable purpose which most people summon up only at odd moments in their lives.

And as generously as he gave, he expected to take. As a man, he regarded the love of woman as his right; as an artist, he expected sympathetic understanding of his art. To him, fame was both necessary and inevitable. Doubtless the only paintings that really moved him were his own, but he respected all kinds—even the worst, since that was what the public most readily appreciated. The death of Bouguereau, for example, affected him deeply. He was sure that he himself was a major artist, and in all likelihood ranked himself among the greatest alive. It seemed only logical to him that everybody else should feel more or less the same way.

This self-esteem was neither arrogant nor assumed. Few artists in history have been less arrogant and less assuming. When his dealer broached the subject of a regular financial subsidy, Rousseau was ready to settle for 20 francs a day, Sundays and holidays included—which for him represented affluence. One day an elderly gentleman knocked at the door, identified himself as Puvis de Chavannes and began to discuss

the fine points of painting. Rousseau never realised that his caller was not the renowned Puvis at all, but an imposter, dressed up by waggish conspirators. He evinced no surprise, moreover, when he read in the paper that a 'M. Rousseau' had won a silver medal, or when Gauguin told him that he had been awarded a government commission, or when he was informed that the President of the Republic expected him at a State reception.

On the contrary, he was astounded to discover that it was another Rousseau who had won the medal, that nobody in the Louvre knew anything about the government commission, and that the attendants at the Elysée refused to let him in. 'I went up to the front door,' he later explained to his friends, 'but they told me that I couldn't get in without a card of invitation. When I insisted, the President himself came out, patted me on the back, and said, "Sorry, Rousseau, but you see you're wearing an ordinary business suit. Since everybody else has on formal clothes, I can't very well receive you today. But come again some other time."'

With little lies like these he tried to bolster his wounded pride. He couldn't believe that anyone would laugh at him and his pictures. But eventually he discovered the truth, and saw that he would have to cope with the situation. He became less frank,

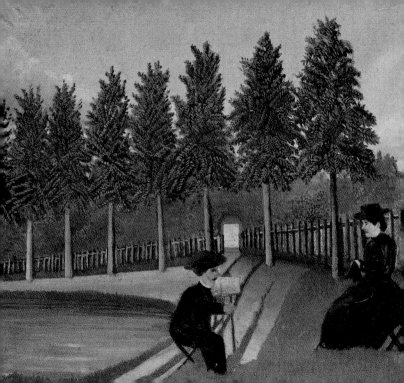

confiding his thoughts to some friends but not to others. He began to adapt and alter facts so as to put himself in the best possible light. One thinks again of the Gospel: 'Behold, I send you forth as sheep in the midst of wolves; be ye therefore wise as serpents and harmless as doves.'

His passion for work, his will power, his unshakeable confidence—these set Rousseau apart from ordinary mortals. His faith in himself was so great that it became an inspiration to others. Unhappy, elderly neighbourhood folk would come to his room and sit quietly in a corner, finding renewed hope in his very presence. There he would sit on a stool, working calmly away at a huge picture. If the afternoon happened to be warm, he might doze off for a few minutes, then, awake with a start and go back to his painting. On one occasion, he turned to some visitors with a curious expression on his face. 'Did you notice', he asked, 'how my hand was moving?'

'Of course, Rousseau. You were filling in that colour with your brush.'

'No, no,' he answered, 'not I. My dead wife was just here and she guided my hand. Didn't you see her or hear her? "Keep at it, Rousseau," she whispered, "you're going to make out all right after all."' He settled back on his stool and worked steadily until sunset.

Who could laugh at such a man? Who could fail to envy his candour, tenacity and genius?

• • •

Goethe once said that dilettantes never can see the difficulties inherent in an undertaking, and consequently are forever lightly trying things beyond their powers. Rousseau was no dilettante. He saw the difficulties clearly enough, and his career in art was a protracted struggle to overcome them. In a matter of 25 years, he poured more creative energy into the struggle than the average man expends in a lifetime.

His pictures were not lightly or idly done. They were not merely the fruit of leisure hours, of visits to museums, of placid reminiscences with friends. They were the product of his inmost vitality, shaped in the course of sleepless nights and arduous days before his easel. He was not simply a recorder; he was a creator. He painted with his whole life, his full heart, his full hopes. His character as an artist was as well-rounded and deep-rooted as a forest oak. It expressed his overpowering faith in the significances of nature and in his own destiny, not merely a desire to 'create' or a delight in plastic form or colour as such. This overpowering faith is the lifeblood of great art. It is one of the qualities that distinguish great art from

that craftsmanship which, however competent, is just good painting.

Rousseau saw the world through the eyes of a wide-eyed child. To most adults, an event, scene, vista or what-not arouses its set responses. These responses will vary from person to person but are generally explicable—translatable into words, forms, colours, perhaps even into music for the piano. To Rousseau, however, life was ever a new experience, mysterious and inexplicable. Beneath the look of things, he felt, lay an inner and arcane essence. Life to him remained an eternal riddle, and the mystical note in his pictures bears witness to the depth of his awe and the breadth of his emotional feeling.

He painted a great many scenes in and about Paris: streets, squares, bridges, the Eiffel Tower and the Trocadéro, the Parc Montsouris, the Buttes Chaumont, the fortifications, Malakoff, villages along the Seine and the Oise.[1] None of these pictures is of particular interest as a documentary record. But all are fascinating imaginative records, in a curious and intensely personal way far surpassing strict documentation. The view of the Eiffel Tower and the Trocadéro as seen through the trees from a bridge over the Seine,

(1) Most of these subjects are known in more than one version

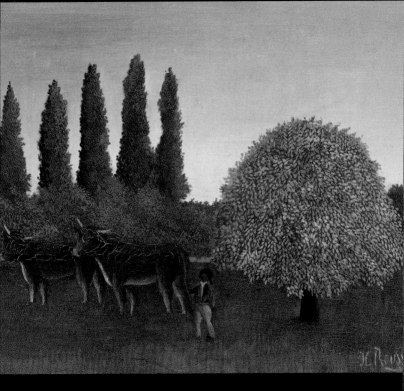

Meadowland (The Pasture), 1910

for example, is hardly 'documentary' in any degree. Yet it is much more; it is a picture of spring, of evening, of youthful desires, of nightingales hidden in the trees and unheard melodies rising from river and bridge.[1]

Or again: on rainy days, heavy clouds like these doubtless hover over Malakoff and Gentilly. But note: they are not mere clouds; they are the shifting curtains behind which awestruck children try to peer when waiting for a glimpse of God hurling down His thunderbolts from heaven. Still again: here is a road on the outskirts of a country town. It has been carefully planted with trees and shrubs which half-hide the barren fields beyond it. Who did not, as a child living in the country, dawdle along this road when taking Sunday walks with the family? How slowly the time dragged by! How dreary life seemed, as we danced along impatiently before our plodding parents! The trees and shrubs mask the dullness of the countryside no better than those Sunday walks masked the monotonies of our existence.[2]

Rousseau knew next to nothing of the fashionable, worldly Paris—the glittering Paris of impeccable

(1) *View of the Eiffel Tower and Trocadéro*, c. 1898, private collection, Paris (2) Untraced

public gardens, stately public buildings and the magnificent Champs Elysées. His was a depressed and depressing city of back streets and barrack-like houses. His affection for it partook of the resigned melancholy of the place itself. His pictures of its streets and scenes are wordless essays on the endurance of the human spirit.

But now and again, this Paris became too depressing for even him to endure, and he withdrew to a lush dream-world of tropical jungle.

Then he would alter the very scale of his work, replacing a small-sized canvas with one that all but filled his little room.

It is a veritable dream-world, out of no garden, zoo or cinema studio, but straight from the fearsome and beautiful shadows of childhood fantasy. Palm groves glisten in the moonlight along a broad river. Lions peer from tall canebrakes; gay-coloured birds perch motionless amid preternaturally large leaves; apes swing from treetop to treetop. In the night the scream of a black man struck down by a panther is heard,[1] or the flute of a black woman luring snakes from their holes.[2] The story goes that while painting

(1) *Jungle with a setting sun*, c. 1910, Kunstmuseum, Basel (2) *The Snake Charmer*, Musée d'Orsay, Paris, illustrated pp. 16-17

these jungle scenes, Rousseau was sometimes so fe-
vered by his conception that he would break off work
and throw open a window for air. His huge landscape
called *The Dream*[1] is a climactic blend of the charms,
horrors, dangers and delights of his imagination—
with Yadwigha lying calmly in the midst of it all on a
red sofa. The secret of the picture's power is not the
striking colour contrast (red sofa *vs.* jungle green), but
the extraordinary evocation of a mysterious and in-
credible world. Rousseau finished it off with a verbal
postscript:

> Yadwigha dans un beau rêve
> S'étant endormie doucement
> Entendait les sons d'une musette
> Dont jouait un charmeur bien pensant.
> Pendante que la lune reflète
> Sur les fleurs, les arbres verdoyants,
> Les fauves serpents prêtent l'oreille
> Aux airs gayes de l'instrument.*

(1) Museum of Modern Art, New York, illustrated overleaf

* Yadwigha lay sleeping sweetly / Wrapped in a blissful dream,
While the liquid notes of a piper / Pervaded the jungle scene.
The moonlight shines down brightly/ On lush jungle flowers and
leaves, / And the lurking serpents listen / To the gay tune the
music weaves.

Overleaf: The Dream, 1910

65

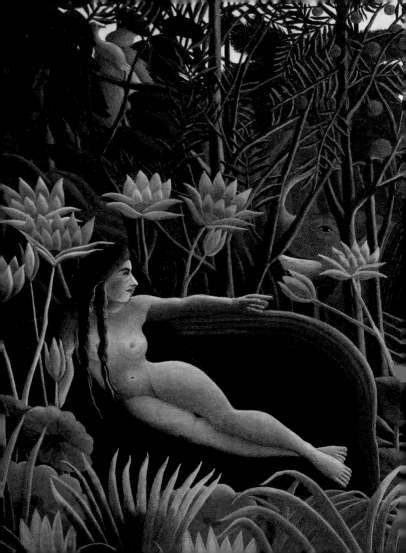

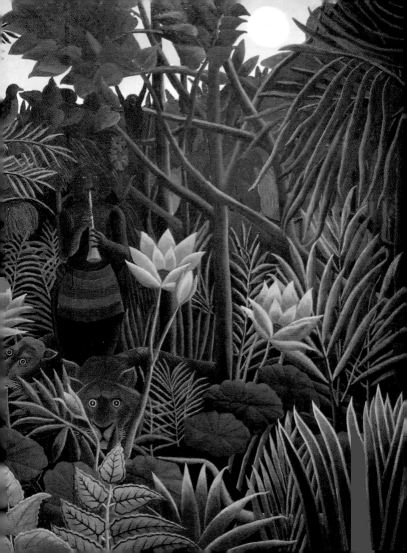

Rousseau's portraits are among his most important works, even though he understood little of the infinite variety of human behaviour. To him, all men were brothers, as Jesus had preached, and he tried his best to say so in his portraits. But within this limit of his capacity, he showed remarkable analytical powers. His first thought was to find settings that would convey what he felt to be the personality of his subjects— not merely those backgrounds which would best accentuate the chosen flesh tones. He posed his beloved young wife, for example, in a flower garden beneath a peaceful, cloud-flecked sky. In all art there are few portraits more eloquent than this. Spring-like odours seem to rise from it, quite as the Nike of Samothrace seems redolent of ocean spray. It is more than portraiture; it is a hymn to youth and love.[1]

In another picture, a young woman stands in a leafy grove, the pink of sunset gleaming through the trees.[2] She has stopped in the course of a promenade and lifted her hand to her heart, as though overcome by the surrounding scene—a most beautiful statement of the hopes and emotions of young womanhood.

(1) *Portrait of a Lady*, Musée d'Orsay, Paris; illustrated p. 35
(2) Kunsthaus, Zürich; illustrated opposite

Opposite: The Promenade in the Forest, 1886

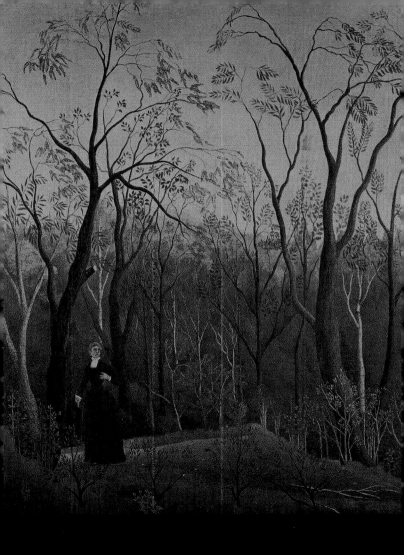

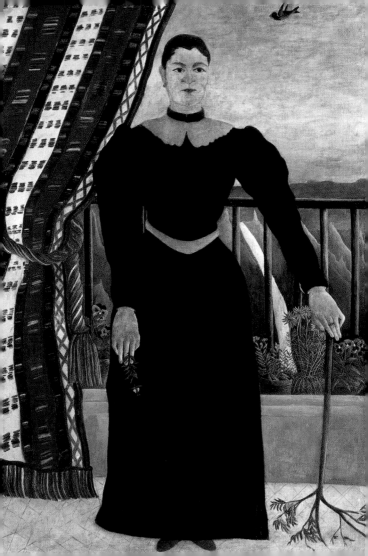

There is also a pair of small portraits of Rousseau and his wife when they were no longer young. The faces stand out from a severe background, but an oil lamp placed boldly in each portrait suggests domestic peace and harmony as no conventionally cluttered interior would have been likely to do.[1]

Particularly noteworthy is a large self-portrait. Rousseau stands proud and solemn, palette in hand, on a *quai* across the Seine from the Louvre.[2] The names of his two wives are written on the palette: *Clémence et Joséphine*. Nearby lies a ship hung with gay pennants and flags. How better could he have testified to his devotion, his self-dedication, his love and his pride? This remarkable painting is a more telling analysis of his life and work than anything a critic could set down on the printed page.

Occasionally he sensed and was able to reproduce peculiar states of mind, as in his portrait (owned by Picasso) of a woman standing on a curtained balcony and holding an inverted leafy bough as though it were a cane.[3] The pose, as well as the bizarre landscape

(1) Both Musée Picasso, Paris; the self-portrait is illustrated p. 1
(2) Národní galerie, Prague; illustrated p. 24 (3) Musée Picasso, Paris, illustrated opposite

Opposite: Portrait of a Woman, c. 1895, originally owned by Picasso

seen through the railing of the balcony, suggests most clearly a neurotic personality. In portraiture as in the rest of his work, Rousseau's imagination sought out latent significances. He posed a child in a meadow sprinkled with tiny blossoms and put a daisy in its hand;[1] but the poet Guillaume Apollinaire is posed behind a row of gaudy, upstanding flowers.[2]

It has been charged that Rousseau's portraits are wretched likenesses. His friend Alfred Jarry is reported to have said that when he came to sit for Rousseau, the artist measured off his nose, mouth, ears, etc., on the handle of his brush, and then reproduced the measurements exactly, without due allowance for perspective.[3] He is also said to have held his paints close to the sitter's face, in order to determine the proper flesh tones. Certainly Rousseau had a number of odd and highly original ways of painting. But if here and there his portraits seem to be poor resemblances, it should be remembered that he was trying to capture what he saw as the personality, and hence was interested in features only as they reflected the heart and mind.

(1) *Child with Doll*, Musée de l'Orangerie, Paris (2) *The Muse inspiring the poet*, first version Kunstmuseum, Basel; illustrated p. 6; second version (with different flowers) Pushkin Museum, St. Petersburg (3) Lost, possibly destroyed by Jarry

Rousseau's sense of form was as highly developed as his sense of fantasy. His work is craftsmanlike as well as creative, his drawing clean and sure. Plants and trees all but live and grow on his canvases; like Corot, he had the great gift of infusing them with reality, branch by branch, leaf by leaf, flower by flower.

His composition is a triumph of space perception, delicately plotted and sensitively balanced. An almost palpable rhythm flows through the *View of Gentilly*, formerly owned by Charles Guérin.[1] What could be more appropriate to the theme than the simple harmonies of design in the portrait of the child with the dangling puppet? In the portrait owned by Picasso, how deftly the various bizarre details are oriented and inter-related by the single detail of the bird in the upper corner! How cleverly placed is the woman in *The Promenade* so as to serve as a focal point for the entire grove! Some of Rousseau's jungle landscapes have a fundamental symmetry found elsewhere only in the work of Poussin. His work in this respect is altogether within the great tradition of French painting.

His sense of colour values was no less notable. The blues, violets and pinks are both subtle and beautiful,

(1) Untraced

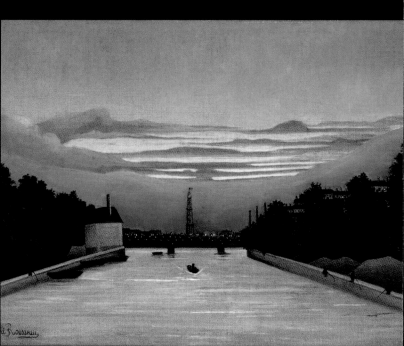

the greens and blacks simply incomparable. Certain of his pictures are done almost entirely in a gamut of greens, and his bold use of black astonished Gauguin and has left lesser painters gasping. 'Matisse's pinks and light greens', I noted in *Picasso et la Tradition Française*, 'are artful and tasteful, Manet's brown is brilliantly effective, but Rousseau's black grips the very soul.' I went on to compare it to the deep note of a tolling cathedral bell, and Matisse's pinks to the gaiety of a breakfast gong. Rousseau had no theory of colour, but fully understood its possibilities and became an absolute master of its effects. The gloomy gray-greens in his view of the Paris fortifications accent precisely the cheerless remoteness of the spot. The pinks, grays and light greens of his *Snake Charmer*, on the other hand, are so seductive that one can almost hear the notes of the snake charmer's flute.

Yet colours, like patterns and forms, were but a means to an end. Translating them to their simplest and most significant terms, Rousseau used them to express what his heart impelled him to say. He studied literal detail, often making drawings in the Jardin des Plantes, or going out in autumn to gather leaves and grasses for examination at home. Much as Pissarro and Sisley had done, he drew sketches from life for certain of his landscapes, among them those of the

fortifications, the Eiffel Tower and the Parc Mont-souris. He was a conscious stylist, interpreting colour, form and pattern in his own way.

When I first met him (through the mother of my friend Robert Delaunay) he was working on *The Snake Charmer*, which now hangs in the Louvre. It did not take me long to realise how passionately he devoted himself to the task of mastering the teeming visions of his brain. Yet as long as he lived, there were critics who could see nothing in his work but naïveté and inanity. These worthies never missed a chance, at the annual Indépendants shows or the *Salons d'Automne*, to display their own naïveté and inanity by poking cheap fun at Henri Rousseau.

• • •

About two years before his death, the Douanier had his first one-man show. A furniture dealer in the Faubourg St. Antoine asked me to hang a few pictures in a room on the Rue Notre Dame des Champs where he was exhibiting his tables and chairs. My first thought was of Rousseau. He himself brought over a number of his works in a pushcart, and we hung them together. I sent out the invitations, but forgot to include the address of our little 'gallery', so only a few visitors appeared. I bought the delightful

Malakoff [1] at the show for 40 francs—about twice what it would have commanded in the open market. His work in general had very little value in those days. He did a large and admirable portrait of an American art dealer named Brummer, who had a prosperous shop on the Boulevard Raspail; and Brummer himself offered me this for 35 francs. [2]

After the Douanier's death there was not enough money to meet his funeral expenses, so the unsold pictures in his room were auctioned off among his friends. The painter Férat bought the now-famous *Wedding* [3] for 200 francs, and I bought the portrait of Rousseau's first wife [4] for the same price. Several years later the pictures had still not increased in value. Even the publication of my little *Henri Rousseau* a year after the artist's death did not greatly alter matters in this respect, although the interest accorded the book and the speed with which the edition was bought up indicated that his work was beginning to be understood. Félix Fénéon, then in charge of the modern section of the Bernheim-Jeune Gallery, agreed at my urging to a full-fledged retrospective show, but the consent

(1) Private collection, Berne (2) Kunstmuseum, Basel, illustrated overleaf (3) Musée de l'Orangerie, Paris, illustrated p. 88
(4) Musée d'Orsay, Paris, illustrated p. 35

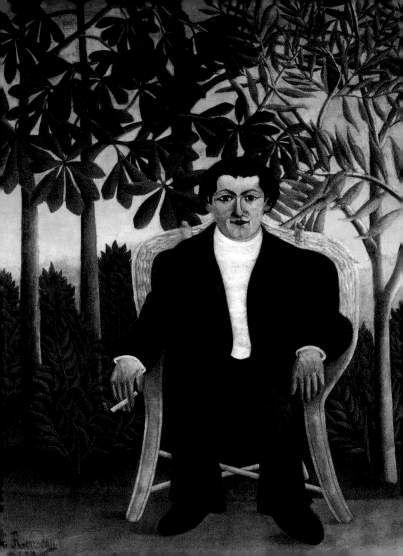

of the Messrs. Bernheim was more difficult to obtain. The exhibition opened at last on October 28, 1912.

For months prior to that date, I spent considerable time trying to locate unknown Rousseaus, visiting people in and about the Plaisance quarter who I knew had been acquainted with the Douanier, and in some streets going from house to house making random inquiries of the concierges. One of my discoveries was in the flat of one of Rousseau's lady friends, a laundress who lived in the Impasse du Maine. There, standing before the fireplace, covered with soot (it had been used as a firescreen), was the charming early picture of a young woman in red walking in a spring wood. The laundress was willing to sell, but could scarcely bring herself to name the price, for she considered it outrageously high: 40 francs.[1]

She added that some relatives of hers, farmers living near Amiens, had other early pictures. I went to see these people, driving out from Amiens in a rain so heavy that I bogged down several times in the mud. They, it developed, had four Rousseaus, but the farmer wasn't at home, and his wife said that she had become too attached to the pictures to think of

(1) Possibly *Woman in Red in the Forest*, private collection, illustrated p. 84

Opposite: Portrait of Joseph Brummer, 1909

79

selling them.[1] Later the farmer wrote a friendly letter inviting me to call and have a chat about Rousseau and a couple of drinks as well. I was bedridden with rheumatism contracted during the moist adventure just concluded, so I had to decline, but eventually managed to buy the pictures anyhow. Nor did I forget to visit Rousseau's daughter. She had married a travelling salesman and was living in Angers. I found, though, that she had only one small picture.[2] The others, I was informed, had 'luckily' been destroyed.

I prepared a preface for the catalogue of the Bernheim-Jeune exhibition. The exhibition itself was successful in that it brought Rousseau's work to the notice of a number of influential people. Important collectors began to show signs of interest, among them Alphonse Kann in Paris and Edwin Suermondt and Paul von Mendelssohn-Bartholdy in Germany. Encouraged by this, I ventured to exhibit a number of the pictures in Germany—as a reward for which, of course, the press heaped mockery upon my head.

Soon, however, the auction of an English collection showed how the tide was turning. Among works

(1) None yet traced (2) *The Merry Jesters*, 1906, Philadelphia Museum of Art

by Degas, Van Gogh, Gauguin and Cézanne were two small sketches and a large jungle scene by Rousseau.[1] The sketches brought 1000 francs each, the jungle scene 9000. Rousseau's portrait of Pierre Loti[2] was put on display in the window of the Rosenberg Gallery on the Avenue de l'Opéra—priced, as I remember it, at 6000 francs. This portrait had been the property of Courteline, popular author of light comedies, who had hung it in his renowned 'Chamber of Horrors'. Courteline simply could not understand why a painting he had always considered a joke should now be worth so large a sum.

Yet the scornful public laughter was by no means stilled. It rang through the cloister on the Boulevard des Invalides as long as I lived there, a tenant of the State, and it followed when I moved myself and my collection to the *quai* opposite the Ile St. Louis. Twice each week, on visiting days, it echoed through my rooms, then down the staircase, into the vestibule and out upon the street—inspired partly by the works of Picasso and Braque, which also hung on my walls, but above all by those of Rousseau.

Nevertheless, one morning brought the proof of impending fame: forgeries. A young man appeared at

(1) Untraced (2) Kunsthaus, Zürich, illustrated overleaf

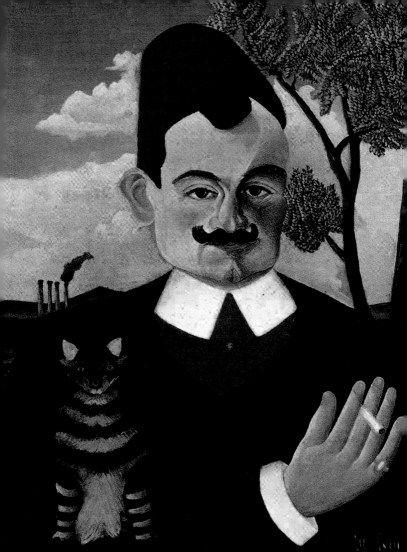

my place with two canvases under his arm, one a picture of a tiger. He explained that these were the work of the great Henri Rousseau, and suggested that I buy them. A single glance sufficed to show that they were bad imitations. I said nothing, but set the pictures next to a genuine work and with a smile and wave of the hand invited comparison. About a week thereafter, when I visited a dealer whose brother later became a Rousseau specialist, he proudly displayed both forgeries as his newest acquisitions. In later years I often saw them in other places.

Then came an experience I shall never forget. On the last day of July, 1914, friends helped me dress and led me downstairs to a carriage. With war inevitable, I had become an enemy alien and had to return to Germany. Since I could move only at a walk—for weeks I had had typhoid fever without realising it, and had run an almost continuous fever of 104°—I had time as I dressed to bid farewell to each of my pictures. There was the portrait of Brummer in his black suit. There was the little girl with a doll in one hand, a daisy in the other. There was the red lady in the spring wood,¹ and *Malakoff*, and *The Promenade*... Each of these pictures

(1) *Woman in Red in the Forest*, private collection, illustrated overleaf

Opposite: Portrait of Pierre Loti, c. 1910

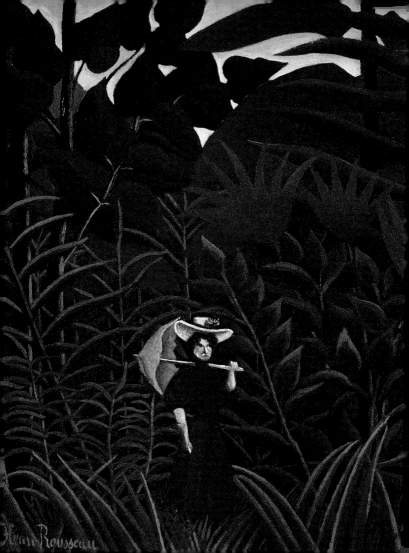

the market, and the inevitable frauds took their place. A German dealer met me on the street one day. 'Ah, you're back!' he observed dryly; 'I suppose you've already dug up some new Rousseaus.' I told him that I hadn't tried to. 'Yesterday,' he went on, 'I was lucky enough to find three for the ridiculous price of 50,000 francs. What do you say to that?'

I said that he had done well if they were genuine, but not so well if they were fakes, and asked him to describe the pictures. When he did so, I explained that I knew them and that they were patent fakes. 'Good God,' he cried, 'what shall I do? I used a customer's money in the deal, and I'm responsible.' 'Well,' I said, 'return the pictures to whoever sold them to you and ask for your money back. Say it was I who told you they were fakes.'

The following day I met the dealer again. He was wreathed in smiles. 'That chap is an angel. Naturally he didn't want to take the pictures back, but he made me a present of a wonderful Rousseau portrait to seal the bargain. "Even your friend won't try to make out that this is bogus," he told me. "The portrait alone is worth more than 50,000 francs."' As might be expected, it wasn't. The portrait was a forgery, too.

Opposite: Eve, c. 1906-7. Uhde kept this for his private collection

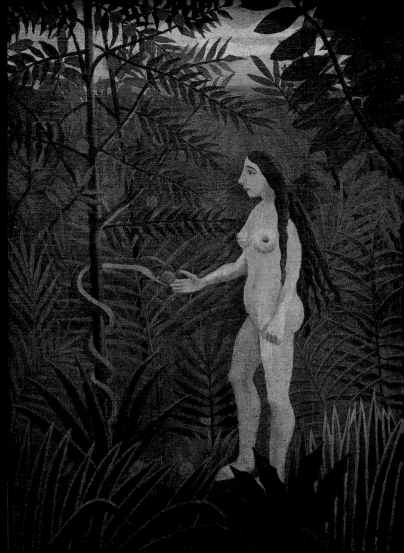

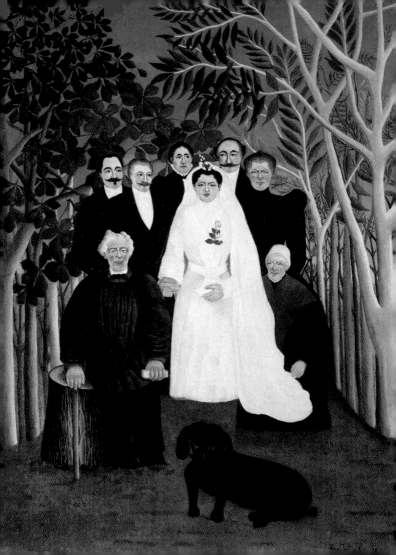

It so happened that I still owned a Rousseau sketch
— a very small but excellent work. I made up my mind
to sell it, for it was the one valuable object I had left,
and I needed the money to start life again in Paris.
Someone told me of a dealer who had recently begun
to specialise in Rousseau. I had known him before the
war, for as a young man he had tried to sell me some
Negro sculptures, and I had once visited his attic on
the Rue des Martyrs. Now when I called he was liv-
ing in a sumptuous apartment in an elegant part of
the city—and, incidentally, had the first Modiglianis
and Soutines I ever saw. He took my little Rousseau
to show to his wife. In a few minutes he came back
to tell me that it wasn't important enough for him to
bother with.

Years later I visited him again, to ask him to lend
me Rousseau's *Wedding* for an exhibition. By then he
had moved to a still larger place in a still more fash-
ionable quarter. At the top of an immense stairway
stood a maître d'hôtel in formal clothes, with a heavy
gold chain around his neck. This dignitary escorted
me into a room, one whole wall of which was cov-
ered with Rousseaus. 'Well, I've never lent the *Wedding*
to anybody,' said its owner, 'but I can hardly refuse

Opposite: The Wedding Party, c. 1905

89

you. There's one qualification, though: you'll have to pay the insurance premium, and that's high, for the picture set me back about 1,000,000 francs.' I could not help thinking sadly of the old days when a few hundred francs had been high for any Rousseau; and when, by foregoing other things I needed or wanted, I could buy their incomparable beauty and have it for my own.

In the interval *The Snake Charmer* had been bought from the elder Mme. Delaunay by the famous collector Doucet; and Doucet, in turn, had bequeathed it to the Louvre. One day a friend rushed up to me on the street and cried, 'Have you heard the news? The Charmer has just been hung!' Tremendously excited, I jumped into a taxi and hastened to the Louvre. Unfortunately, the gallery with the Corots, Manets, Degases, etc., was not open. A watchman told me that part of the roof had fallen and that it would take several weeks to repair the damage. But he confirmed the great news I had heard, adding that a picture by Manet had been rehung to make room for the picture by Rousseau.

The moment finally came when I saw it hanging on the wall in all its splendour. I thought of the little Douanier, now ranked a master among masters. I thought too of the time when he and I were probably

the only people on earth who considered this even a remote possibility.

Not many years later the Louvre was closed and its pictures hidden away. Once again war impended. When this war too was won and France was again free, it so happened that there were few qualified Rousseau experts on hand. Perhaps it was assumed that they had died or otherwise vanished forever; in any event, there was issued in Paris a Rousseau study illustrated with upward of 25 forgeries. And Maximilien Gauthier identified about half the pictures at a certain Rousseau show as downright frauds.

A genuine work of prime quality, however, long considered lost, turned up during this period. Entitled *War*, it too was acquired by the Louvre. A half century earlier—in 1894—Rousseau had foreseen, through the magical medium of great art, the horrors experienced by humanity during recent years.

Overleaf: War (Discord on Horseback), 1894

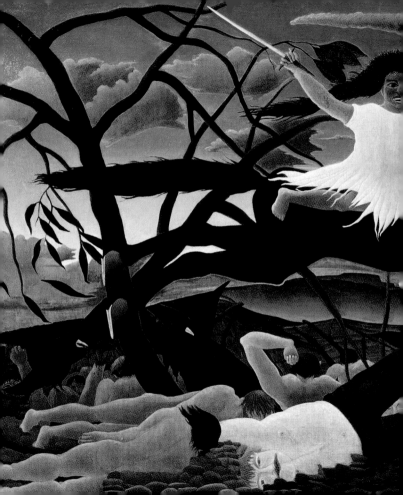

List of illustrations

pp. 54-55 Tropical Forest with Monkeys, 1910, 129 x 162 cm,
National Gallery of Art, Washington, DC
p. 58 The Artist Painting his Wife, 1900-1905, 65 x 56 cm, Private Collection
p. 62 Meadowland (The Pasture), 1910, 46 x 55 cm,
Bridgestone Museum of Art, Tokyo
pp. 66-67 The Dream, 1910, 201 x 298 cm,
The Museum of Modern Art, New York
p. 69 The Promenade in the Forest, c. 1886, 70 x 60 cm,
Kunsthaus, Zürich
p. 70 Portrait of a Woman, 1895, 160 x 105 cm,
Musée Picasso, Paris
p. 74 The Eiffel Tower, c. 1898, 52 x 77 cm,
Museum of Fine Art, Houston
p. 78 Portrait of Joseph Brummer, 1909, 118 x 88 cm, Private Collection
p. 82 Portrait of Pierre Loti, c. 1910, 61 x 50 cm,
Kunsthaus, Zürich
p. 84 Woman in Red in the Forest, c. 1907, 75 x 59 cm, Private Collection
p. 87 Eve, c. 1906-7, 61 x 46 cm,
Kunsthalle, Hamburg
p. 88 The Wedding Party, c. 1905, 163 x 114 cm,
Musée de l'Orangerie, Paris
pp. 92-93 War (Discord on Horseback), 1894, 114 x 195 cm,
Musée d'Orsay, Paris

Illustrations on pp. 58, 73, 69 and 84 © Bridgeman Art Library; on
pp. 40-41 courtesy J. Paul Getty Museum; on pp. 2 and 51 courtesy
The Barnes Foundation; on pp. 1, 4, 6, 9, 16-17, 20-21, 24, 28-29,
32, 25, 38, 44, 46-47, 62, 66-67, 70, 74, 82, 88 and 92-93
courtesy Wikimedia Commons; on p. 87 Wikimedia
Commons, courtesy ArishG; on pp. 54-55
courtesy National Gallery of Art,
Washington, DC

© 2005, 2018 Pallas Athene

Published in the United States of America by the J. Paul Getty Museum, Los Angeles
Getty Publications
1200 Getty Center Drive, Suite 500
Los Angeles, California 90049-1682
www.getty.edu/publications

Distributed in the United States and Canada by the University of Chicago Press

Printed in China

ISBN 978-1-60606-567-9
Library of Congress Control Number: 2017948425

Published in the United Kingdom by Pallas Athene (Publishers) Limited
Studio 11A, Archway Studios, 25–27 Bickerton Road, London N19 5JT

Series editor: Alexander Fyjis-Walker
Editorial assistant: Anaïs Métais

Note on the Text
Wilhelm Uhde first published his *Recollections of Henri Rousseau* in 1911, as a monograph in a new series about modern art issued by Apollinaire's publisher, Eugène Figuière. It was the first publication about Rousseau. Uhde revised the text over the following decades, publishing versions in both French and German. The text presented here is the last such revision. It was translated by Ralph Thompson and published in 1949 as part of a book entitled *Five Primitive Masters*. It is published here by generous permission of Dina Vierny.